Creating with Code

A Fun Exploration of Computer-Generated Images and Machine Learning

Dr. J. J. Weiler

Orange Loop Press

Somerville, MA
Orange Loop Press
http://orangelooppress.com/

Library of Congress Control Number: 2021913450

ISBN: 978-1-7372188-1-4

First Edition

for Suhas

TABLE OF CONTENTS

IS A COMICS CREATOR
WHO ENJOYS USING
COMPUTER PROGRAMMING
TO MAKE AND ALTER
IMAGES.

IS A RESEARCHER
WHO SPECIALIZES
IN MACHINE
LEARNING.

1

COMPUTER PROGRAMMING AND CREATING IMAGES

FIRST OF ALL, MAKING CERTAIN TYPES OF IMAGES IS JUST *FASTER* AND *EASIER* TO DO WITH CODE.

ALSO, WHEN CODING, I ONLY NEED MY COMPUTER WITH ME, RATHER THAN MY ART SUPPLIES OR EXTERNAL DRAWING TABLET.

IT ALSO ALLOWS ME TO HAVE A CREATIVE OUTLET WHEN I'M FACING PHYSICAL LIMITATIONS...

...SUCH AS WHEN I INJURED MY HAND AND COULDN'T DRAW WITHOUT BEING IN PAIN.

AND MOST IMPORTANTLY, I LIKE TO EXPERIMENT AND TRY DIFFERENT CREATIVE APPROACHES.

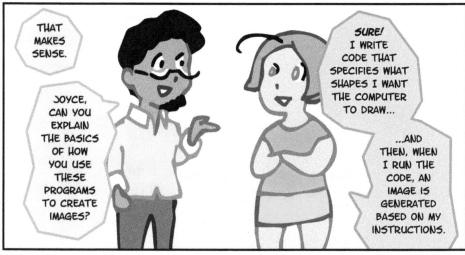

THAT MAKES SENSE.

JOYCE, CAN YOU EXPLAIN THE BASICS OF HOW YOU USE THESE PROGRAMS TO CREATE IMAGES?

SURE! I WRITE CODE THAT SPECIFIES WHAT SHAPES I WANT THE COMPUTER TO DRAW...

...AND THEN, WHEN I RUN THE CODE, AN IMAGE IS GENERATED BASED ON MY INSTRUCTIONS.

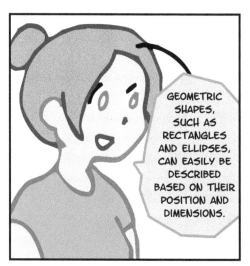

GEOMETRIC SHAPES, SUCH AS RECTANGLES AND ELLIPSES, CAN EASILY BE DESCRIBED BASED ON THEIR POSITION AND DIMENSIONS.

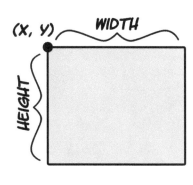

AND, WITH A LITTLE TIME AND ATTENTION, I CAN POSITION A BUNCH OF SHAPES TO CREATE A NICE IMAGE.

FOR EXAMPLE, HERE'S AN EYE I CREATED PROGRAMMATICALLY BY SPECIFYING THE SIZE, POSITION, AND COLOR OF SEVERAL ELLIPSES.

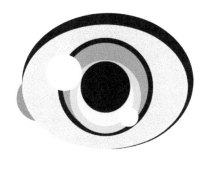

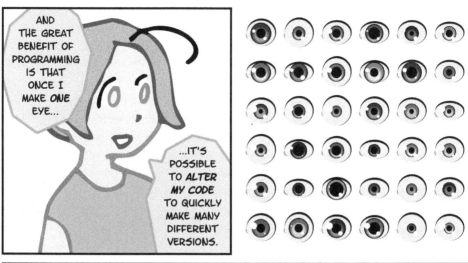

AND THE GREAT BENEFIT OF PROGRAMMING IS THAT ONCE I MAKE *ONE* EYE...

...IT'S POSSIBLE TO *ALTER MY CODE* TO QUICKLY MAKE MANY DIFFERENT VERSIONS.

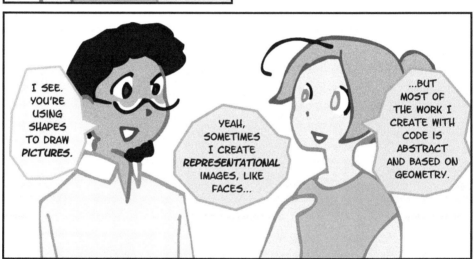

I SEE. YOU'RE USING SHAPES TO DRAW *PICTURES.*

YEAH, SOMETIMES I CREATE *REPRESENTATIONAL* IMAGES, LIKE FACES...

...BUT MOST OF THE WORK I CREATE WITH CODE IS ABSTRACT AND BASED ON GEOMETRY.

FOR EXAMPLE...

...I CAN CREATE ARCS BY PLACING A SERIES OF SHAPES.

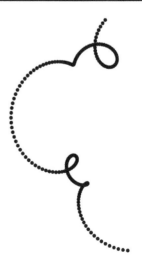

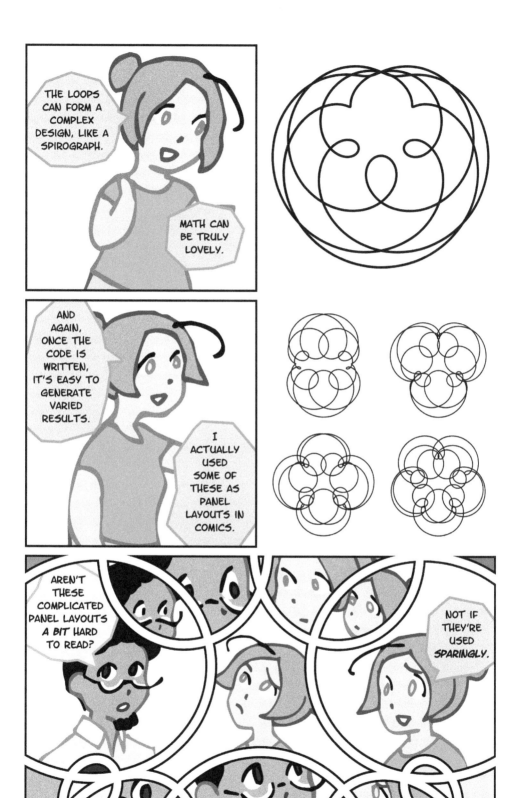

CREATING *TEXTURED IMAGES* BY DRAWING SIMPLE SHAPES IS A BIT MORE DIFFICULT...

...BECAUSE YOU HAVE TO LAYER LOTS OF *TRANSLUCENT* SHAPES.

BUT ONCE THE CODE IS WRITTEN, THE RESULTS CAN BE REALLY BEAUTIFUL.

FOR ONE OF MY FIRST PROGRAMMING PROJECTS, I CREATED A SERIES OF RANDOMLY GENERATED LINES.

BY DRAWING LINES OVER AND OVER IN SLIGHTY DIFFERENT POSITIONS, IT'S POSSIBLE TO BUILD UP A COLORFUL VISUAL TEXTURE.

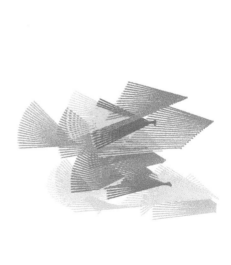

14

AND IN MANY DRAWING PROGRAMS*, I CAN EASILY RUN THIS CODE AS AN ANIMATION THAT KEEPS DRAWING MORE AND MORE LINES IN DIFFERENT POSITIONS.

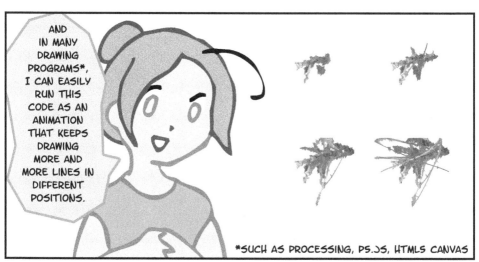

*SUCH AS PROCESSING, P5.JS, HTML5 CANVAS

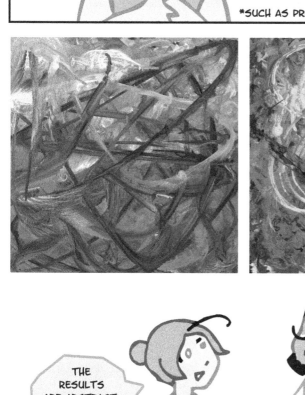

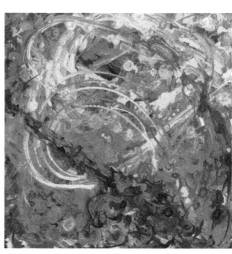

THE RESULTS ARE ABSTRACT, TEXTURED, AND COLORFUL.

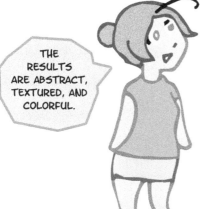

I THINK THEY LOOK BEAUTIFUL.

WELL DONE.

ON THE OTHER HAND, THE DATA IN IMAGES CAN BE READ AND ALTERED PROGRAMMATICALLY.

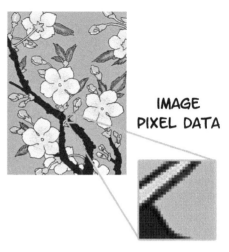

IMAGE PIXEL DATA

ORIGINAL IMAGE

DIGITALLY REDRAWN VERSIONS

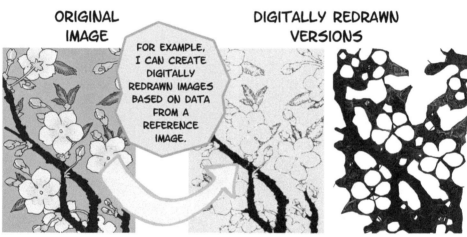

FOR EXAMPLE, I CAN CREATE DIGITALLY REDRAWN IMAGES BASED ON DATA FROM A REFERENCE IMAGE.

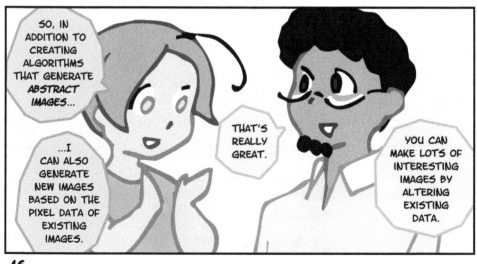

SO, IN ADDITION TO CREATING ALGORITHMS THAT GENERATE ABSTRACT IMAGES...

...I CAN ALSO GENERATE NEW IMAGES BASED ON THE PIXEL DATA OF EXISTING IMAGES.

THAT'S REALLY GREAT.

YOU CAN MAKE LOTS OF INTERESTING IMAGES BY ALTERING EXISTING DATA.

BUT I *KNOW* THERE IS *SO MUCH MORE* THAT CAN BE DONE.

I WANT TO SEE WHAT ELSE COMPUTERS ARE CAPABLE OF.

AND THAT'S WHY YOU WANT TO FIND OUT MORE ABOUT *MACHINE LEARNING?*

YEAH. RIGHT NOW, ALL THE IMAGES I CREATE ARE BASED ON EXPLICIT INSTRUCTIONS THAT I WROTE IN THE PROGRAM.

I WOULD LIKE TO SEE WHAT HAPPENS IF AN ALGORITHM IS GIVEN A CHANCE TO GROW AND CHANGE.

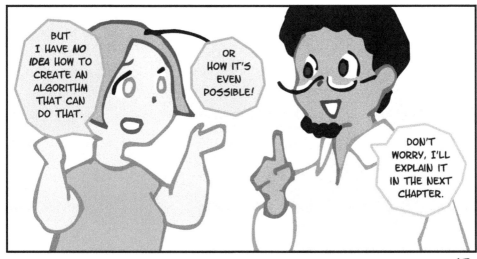

BUT I HAVE *NO* IDEA HOW TO CREATE AN ALGORITHM THAT CAN DO THAT.

OR HOW IT'S EVEN POSSIBLE!

DON'T WORRY, I'LL EXPLAIN IT IN THE NEXT CHAPTER.

2
HOW MACHINES CAN LEARN

MACHINE LEARNING
REFERS TO THE STUDY OF COMPUTER ALGORITHMS THAT IMPROVE AUTOMATICALLY THROUGH EXPERIENCE.

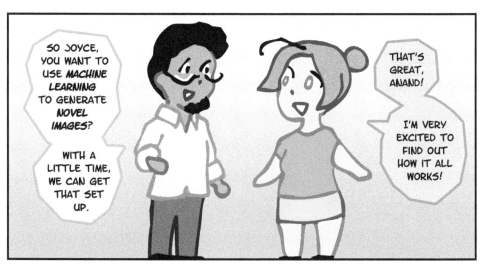

SO TINY!!

SUCH LOW RESOLUTION!!

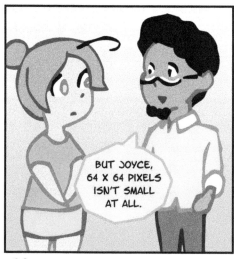

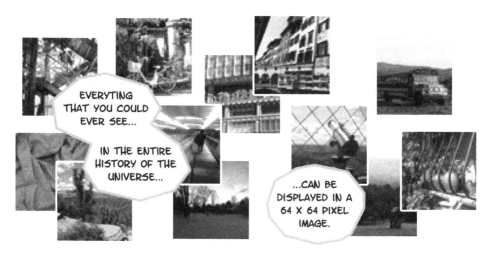

EVERYTING THAT YOU COULD EVER SEE...

IN THE ENTIRE HISTORY OF THE UNIVERSE...

...CAN BE DISPLAYED IN A 64 X 64 PIXEL IMAGE.

FURTHERMORE, EVERY SIGHT THAT WILL NEVER EXIST CAN ALSO BE DEPICTED.

YOU AND ME, BOTH FIVE YEARS OLD, STANDING ON MARS—

—THAT COULD EXIST IN AN IMAGE.

AND BEYOND THAT— THERE ARE ALL THE POSSIBLE NON-REPRESENTATIONAL AND NONSENSE IMAGES.

AN *ALGORITHM* SUCCESSFULLY GENERATING A *NOVEL* 64 X 64 PIXEL IMAGE...

...GIVEN ALL *THE POSSIBILITIES* OF WHAT THAT IMAGE COULD BE...

...IS AN *AMAZING* FEAT.

WOW! YOU'RE RIGHT!

I HAVE A *HARD TIME* IMAGINING HOW A COMPUTER CAN ACCOMPLISH SUCH A *COMPLEX* TASK!

WHILE *IMAGES* CAN BE COMPLEX...

...THE MECHANISMS NEEDED TO CREATE THEM ARE VERY STRAIGHTFORWARD ONCE YOU UNDERSTAND THE **MATH.**

HOLD ON A SECOND, *MATH?*

ANAND, WE *TOLD* THE READERS THAT THIS COMIC WOULDN'T BE *TOO* TECHNICAL.

DONT WORRY, I'M JUST GOING TO BROADLY EXPLAIN THE RELEVANT CONCEPTS.

WE'LL BEGIN WITH A SIMPLE EXAMPLE.

LET'S SAY THAT THERE IS A DATASET OF XY POINTS...

...AND WE WANT TO GENERATE NEW, SIMILAR POINTS.

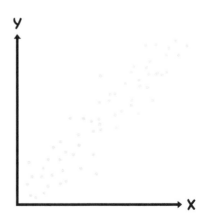

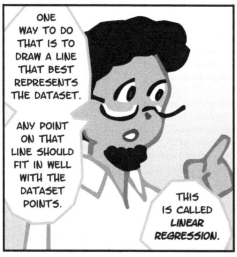

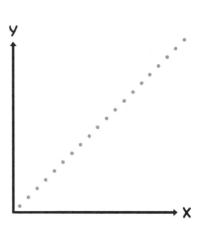

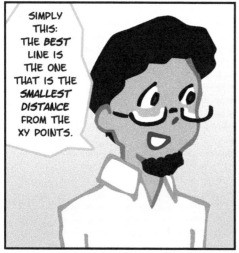

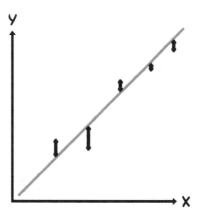

BY COMPARING THE DISTANCE BETWEEN *POINTS GENERATED BY OUR LINES* TO THE POINTS IN OUR DATASET, WE CAN FIND THE SLOPE AND POSITION OF THE LINE THAT BEST FITS THE DATA.

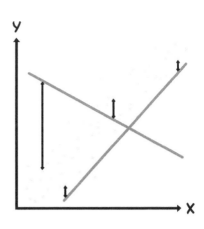

*STRAIGHT LINE EQUATION: $Y = MX + B$

BUT WHAT IF THE XY DATA LOOKS LIKE THIS?

THERE'S NO STRAIGHT LINE THAT WILL REPRESENT THIS DATASET WELL.

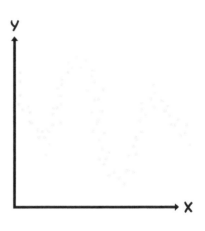

WELL, YOU WOULD NEED A MORE *COMPLEX EQUATION* TO DESCRIBE THIS DATASET IN A *MATHEMATICAL MODEL.*

YES. YOU WOULD WANT TO USE *NONLINEAR* REGRESSION.

OKAY, BUT HOW DO YOU *DO* THAT?

WELL, THAT'S WHERE THE *MACHINE LEARNING* COMES IN.

ONE OPTION IS TO USE A **NEURAL NET.**

NEURAL NET?

WHAT'S THAT?

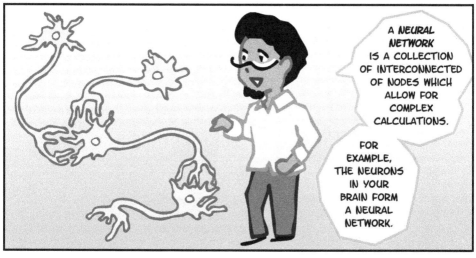

A **NEURAL NETWORK** IS A COLLECTION OF INTERCONNECTED OF NODES WHICH ALLOW FOR COMPLEX CALCULATIONS.

FOR EXAMPLE, THE NEURONS IN YOUR BRAIN FORM A NEURAL NETWORK.

IN AN **ARTIFICIAL NEURAL NETWORK,** THE COMPUTER IS GIVEN AN INPUT, WHICH IS THEN SENT TO SEVERAL INTERCONNECTED NODES.

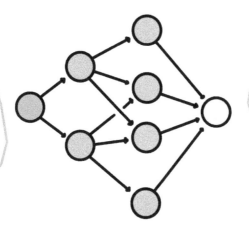

EACH NODE RECEIVES INPUT AND COMPUTES AN OUTPUT, WHICH IT SENDS ON TO THE NEXT NODE.

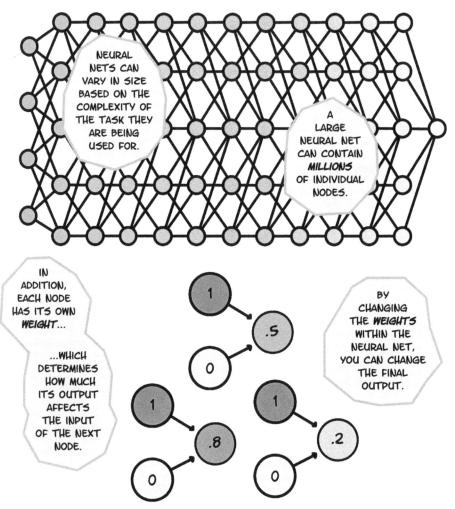

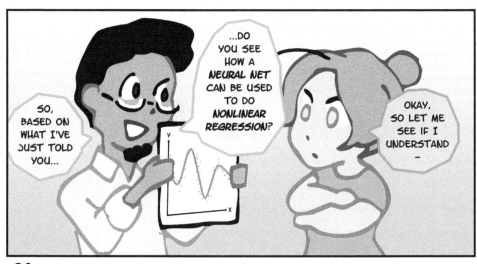

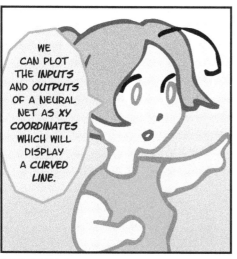

WE CAN PLOT THE *INPUTS* AND *OUTPUTS* OF A NEURAL NET AS *XY COORDINATES* WHICH WILL DISPLAY A *CURVED LINE.*

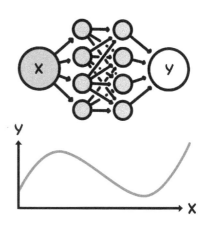

BY CHANGING THE *WEIGHTS* IN THE NEURAL NET

...WE CAN CREATE DIFFERENT VERSIONS, WHICH WILL GENERATE DIFFERENT POINTS.

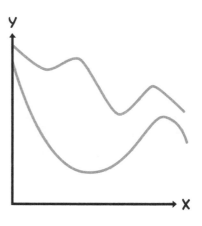

AND, EVENTUALLY, WE WILL FIND A *VERSION OF THE NEURAL NET* THAT PRODUCES POINTS THAT ARE CLOSE TO THE XY POINTS IN THE DATASET.

THAT'S RIGHT.

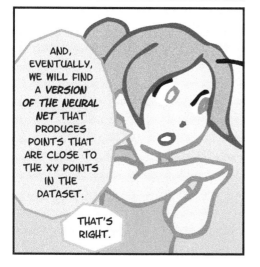

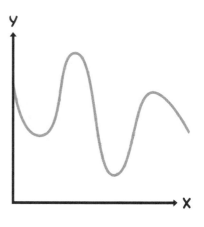

27

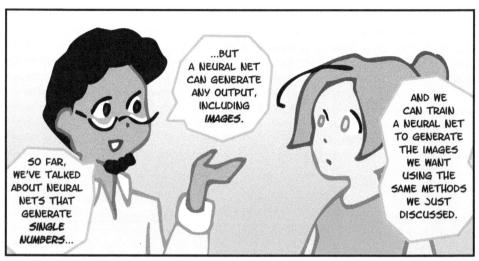

SO FAR, WE'VE TALKED ABOUT NEURAL NETS THAT GENERATE *SINGLE NUMBERS*...

...BUT A NEURAL NET CAN GENERATE ANY OUTPUT, INCLUDING *IMAGES*.

AND WE CAN TRAIN A NEURAL NET TO GENERATE THE IMAGES WE WANT USING THE SAME METHODS WE JUST DISCUSSED.

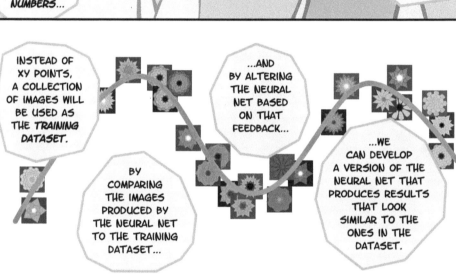

INSTEAD OF XY POINTS, A COLLECTION OF IMAGES WILL BE USED AS THE *TRAINING DATASET*.

BY COMPARING THE IMAGES PRODUCED BY THE NEURAL NET TO THE TRAINING DATASET...

...AND BY ALTERING THE NEURAL NET BASED ON THAT FEEDBACK...

...WE CAN DEVELOP A VERSION OF THE NEURAL NET THAT PRODUCES RESULTS THAT LOOK SIMILAR TO THE ONES IN THE DATASET.

OH, I SEE!

SO I'LL BE MAKING A NEURAL NET THAT WILL GENERATE IMAGES!

IN ORDER TO CREATE NOVEL IMAGES THAT RESEMBLE THOSE IN THE TRAINING DATASET, I WOULD SUGGEST USING *TWO* NEURAL NETS.

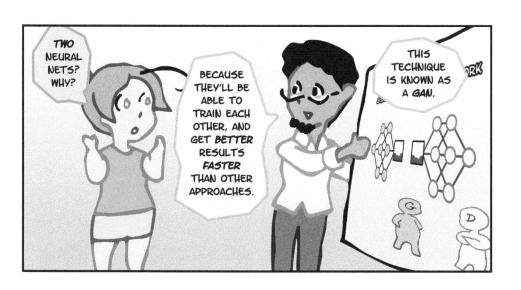

G.A.N.
GENERATIVE ADVERSARIAL NETWORK

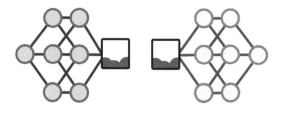

GANs ARE A MACHINE LEARNING APPROACH IN WHICH TWO NEURAL NETS, WHICH WE CALL THE *GENERATOR* AND THE *DISCRIMINATOR*, CONTEST EACH OTHER, WITH THE ULTIMATE OUTCOME THAT *BOTH* PRODUCE BETTER RESULTS.

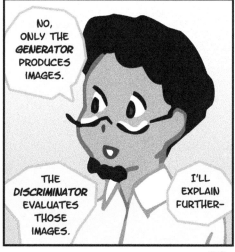

THE **GENERATOR** IS A NEURAL NET WHICH WILL TAKE IN RANDOM NUMBERS AND OUTPUT IMAGES.

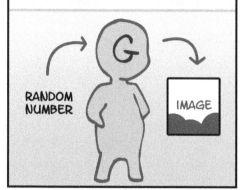

THE GENERATOR'S JOB IS TO CREATE IMAGES THAT RESEMBLE THE ONES IN THE **TRAINING DATASET**.

BUT THE RESULTS WILL NOT BE GOOD. THAT'S WHY THE DISCRIMINATOR EXISTS.

THE **DISCRIMINATOR** IS A NEURAL NET WHICH WILL TAKES IN IMAGES AND OUTPUTS EITHER "TRUE" OR "FALSE."

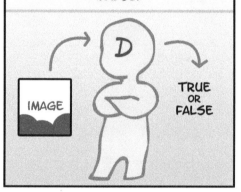

THE DISCRIMINATOR'S JOB IS TO DETERMINE IF THE IMAGE IT'S GIVEN IS PART OF THE TRAINING DATASET (TRUE), OR A FAKE CREATED BY THE GENERATOR (FALSE).

AT FIRST, BOTH THE GENERATOR AND THE DISCRIMINATOR ARE *PRETTY BAD* AT WHAT THEY DO.

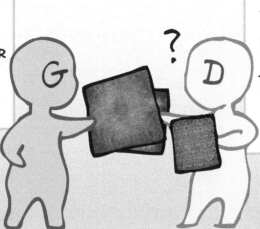

AFTER ALL, THEY START OUT AS A RANDOMIZED SERIES OF NODES THAT AREN'T ATTUNED TO THE TRAINING DATASET.

BUT ONCE THE DISCRIMINATOR IS DONE COMPARING EACH BATCH OF IMAGES, THE GENERATOR IS SHOWN WHICH FAKE IMAGES FOOLED THE DISCRIMINATOR, AND WHICH DIDN'T.

THE GENERATOR IS ALTERED BASED ON THIS FEEDBACK.

THE DISCRIMINATOR IS ALSO SHOWN WHICH IMAGES IT CORRECTLY ASSIGNED, AND WHICH WERE WRONG.

THE DISCRIMINATOR IS ALTERED BASED ON THIS FEEDBACK.

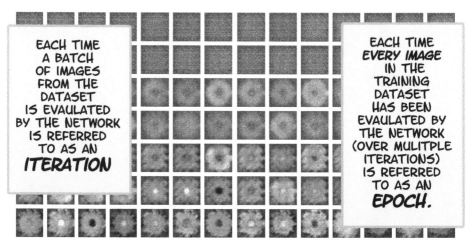

EACH TIME A BATCH OF IMAGES FROM THE DATASET IS EVAULATED BY THE NETWORK IS REFERRED TO AS AN **ITERATION**

EACH TIME *EVERY IMAGE* IN THE TRAINING DATASET HAS BEEN EVAULATED BY THE NETWORK (OVER MULITPLE ITERATIONS) IS REFERRED TO AS AN **EPOCH.**

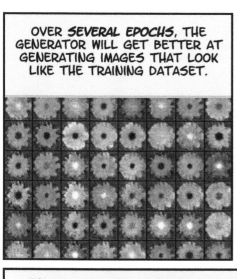

OVER *SEVERAL EPOCHS*, THE GENERATOR WILL GET BETTER AT GENERATING IMAGES THAT LOOK LIKE THE TRAINING DATASET.

AND THE DISCIRMINATOR WILL GET BETTER AT SEEING THE MINUTE DIFFERENCES BETWEN THE DATASET IMAGES AND THE FAKES.

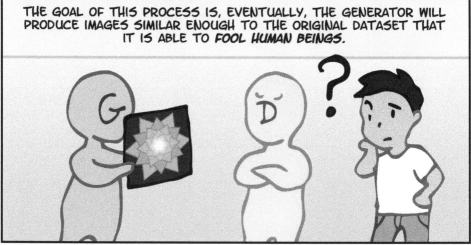

THE GOAL OF THIS PROCESS IS, EVENTUALLY, THE GENERATOR WILL PRODUCE IMAGES SIMILAR ENOUGH TO THE ORIGINAL DATASET THAT IT IS ABLE TO *FOOL HUMAN BEINGS.*

HOWEVER, GAN RESULTS AREN'T ALWAYS SUCCESSFUL. SOMETIMES, THE GENERATOR AND DISCRIMINATOR REACH A STANDSTILL, AND THE RESULTS STOP GETTING BETTER.

AND SOMETIMES A GAN CAN ACTUALLY START PRODUCING **WORSE** RESULTS AFTER ADDITIONAL TRAINING.

WOW. SO IT'S VERY SIMILIAR TO HOW HUMAN BEINGS LEARN, ISN'T IT?

GANs CAN EVEN **GET STUCK** LIKE PEOPLE SOMETIMES DO.

WELL, NOT REALLY.

WHILE THE PROCESS CAN BE DESCRIBED AS **LEARNING**, WE ARE STILL DEALING WITH **ALGORITHMS** AND **NOT** PEOPLE.

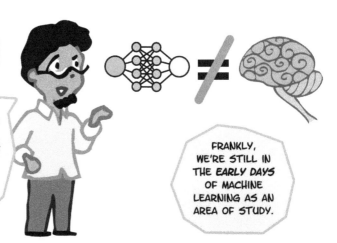

DESPITE ADVANCES IN TECHNOLOGY...

...THERE IS STILL *NO COMPARISION* BETWEEN THE INTELLIGENCE OF A COMPUTER PROGRAM AND A HUMAN BRAIN.

FRANKLY, WE'RE STILL IN THE *EARLY DAYS* OF MACHINE LEARNING AS AN AREA OF STUDY.

WE ARE DISCOVERING MORE ABOUT HOW THESE SYSTEMS WORK...

...BUT WE DON'T YET HAVE AN ENCOMPASSING *THEORY OF INTELLIGENCE.*

IMAGINE TRYING TO UNDERSTAND *PHYSICS* WITHOUT HAVING A *THEORY OF GRAVITY.*

THAT'S ABOUT WHERE WE ARE.

WOW. MACHINE LEARNING IS STILL IN ITS INFANCY.

DEFINITELY. MORE RESEARCH IS NEEDED.

AFTER ALL, FUTURE ADVANCEMENTS COULD BE VERY VALUABLE, BOTH TO THE SCIENTIFIC COMMUNITY AS WELL AS SOCIETY AT LARGE.

ARE ALL ADVANCEMENTS IN MACHINE LEARNING *OPENLY SHARED?*

OR ARE NEW RESEARCH AND DISCOVERIES KEPT PRIVATE?

WELL, RESEARCHERS WILL TEMPORARILY CONCEAL NEWLY DEVELOPED ALGORITHMS OR APPLICATIONS UNTIL THEY CAN PUBLISH THEIR RESULTS IN CONFERENCES OR JOURNALS...

...AND, IN SOME CASES, CORPORATIONS WILL REFRAIN FROM PUBLISHING *AT ALL,* SO THAT THEIR RESEARCH AND DEVELOPED TECHNOLOGY REMAINS KNOWN SOLELY TO THE COMPANY.

OH. IN THAT CASE, WILL IT BE HARD FOR ME TO LEARN HOW TO TRAIN MY OWN GAN?

NO, THE TYPE OF RESEARCH I'M DESCRIBING IS FAR BEYOND ANYTHING THAT YOU'LL NEED TO CREATE AND TRAIN A BASIC GAN.

EVERYTHING RELATED TO WHAT YOU WILL BE DOING IS READILY AVAILABLE.

USING A GAN TO GENERATE NEW IMAGES BASED ON A TRAINING DATASET IS **STRAIGHTFORWARD** AND **ESTABLISHED** IN MACHINE LEARNING...

...AND THERE ARE MANY **EXAMPLES** AND **TUTORIALS** TO HELP YOU.

THERE ARE BOOKS AVAILABLE, BOTH FOR BEGINNERS AND PEOPLE WITH PROGRAMMING EXPERIENCE.*

*FURTHER READING (PAGE 98)

BUT YOUR **GREATEST** RESOURCE...

...WILL BE ALL THE EXAMPLES AVAILABLE ON THE INTERNET.

GOOD POINT. THE INTERNET IS AN **AMAZING** RESOURCE, ESPECIALLY WHEN LEARNING ABOUT COMPUTER PROGRAMMING.

THROUGH ONLINE REFERENCES, I PRETTY MUCH TAUGHT MYSELF HTML AND CSS.

YES. THERE ARE ALSO **ARTICLES** AND **STEP-BY-STEP EXAMPLES** THAT ARE POSTED BY PROGRAMMERS FROM AROUND THE WORLD.

HOWEVER, MOST OF THOSE ASSUME THAT THE READER WILL ALREADY HAVE BASIC KNOWLEDGE OF PROGRAMMING.

AND THERE ARE A FEW OTHER THINGS TO KEEP IN MIND—

—FIRST, ONLINE EXAMPLES ARE OFTEN SET UP TO WORK WITH A **SPECIFIC VERSION** OF SOFTWARE...

...SO YOU MAY HAVE TO ALTER THE CODE TO WORK WITH THE VERSION YOU HAVE.

SECOND, THERE ARE OFTEN TYPOS OR ERRORS IN EXAMPLE CODE.

THAT'S WHY GOOD EXAMPLES INCLUDE COMMENTS FOR ANY CORRECTIONS AND UPDATES.

SO, NOW THAT WE'VE GONE OVER THE BASICS OF MACHINE LEARING...

...DO YOU FEEL READY TO GET STARTED?

I THINK SO!

AT LEAST, I'M DEFINITELY EXCITED TO SEE WHAT'S GOING TO HAPPEN IN THE NEXT CHAPTER!

3
RUNNING A GAN

CURRENLTY, **PYTHON** IS VERY POPULAR FOR WRITING MACHINE LEARNING ALGORITHMS.

PYTHON IS A GENERAL-PURPOSE PROGRAMMING LANGUAGE THAT WAS CREATED IN THE 1990s.

THE FIRST THING YOU WILL NEED TO DO IS DOWNLOAD A **PYTHON IDE*** SO THAT YOU CAN RUN PYTHON CODE ON YOUR COMPUTER.

*IDE: INTEGRATED DEVELOPMENT ENVIRONMENT

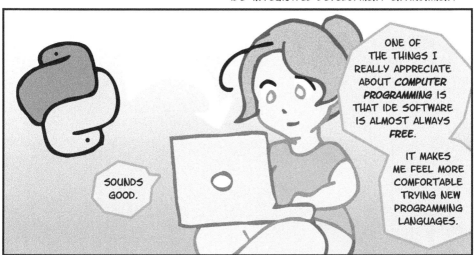

ONE OF THE THINGS I REALLY APPRECIATE ABOUT **COMPUTER PROGRAMMING** IS THAT IDE SOFTWARE IS ALMOST ALWAYS **FREE.**

IT MAKES ME FEEL MORE COMFORTABLE TRYING NEW PROGRAMMING LANGUAGES.

SOUNDS GOOD.

OKAY, I'VE GOT EVERYTHING DOWNLOADED AND THE IDE IS RUNNING SUCCESSFULLY.

AWESOME! AS WE GO, YOU MAY NEED TO DOWNLOAD ADDITIONAL MODULES OR LIBRARIES.*

*IN COMPUTER PROGRAMMING, A **LIBRARY** IS A COLLECTION OF FUNCTIONS THAT CAN BE USED BY OTHER PROGRAMS

BEFORE I TRY CREATING CUSTOM RESULTS, I'M GOING TO RUN A TEST TO MAKE SURE I CAN GET A MACHINE LEARNING PROGRAM TO WORK ON MY COMPUTER.

TO DO THIS, I'M FOLLOWING AN INTRODUCTION TO MACHINE LEARNING TUTORIAL.

AND FOR THE DATASET, I'M USING A DATABASE OF IMAGES OF HANDWRITTEN NUMBERS.*

*THE MNIST DATABASE OF HANDWRITTEN DIGITS

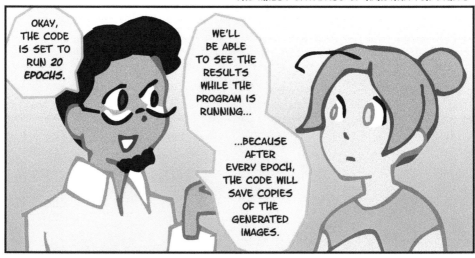

OKAY, THE CODE IS SET TO RUN 20 EPOCHS.

WE'LL BE ABLE TO SEE THE RESULTS WHILE THE PROGRAM IS RUNNING...

...BECAUSE AFTER EVERY EPOCH, THE CODE WILL SAVE COPIES OF THE GENERATED IMAGES.

OKAY, THE CODE LOOKS GOOD, SO TRY RUNNING IT.

OK!

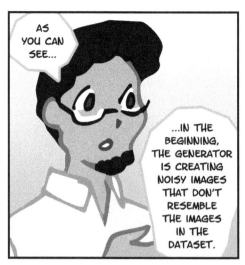

AS YOU CAN SEE...

...IN THE BEGINNING, THE GENERATOR IS CREATING NOISY IMAGES THAT DON'T RESEMBLE THE IMAGES IN THE DATASET.

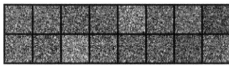

0 EPOCHS

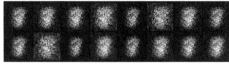

2 EPOCHS

HOWEVER, AS THE GENERATOR AND DESCRIMINATOR ARE TRAINED OVER SEVERAL EPOCHS...

...THE IMAGES BEING CREATED BEGIN TO RESEMBLE HANDWRITTEN NUMBERS.

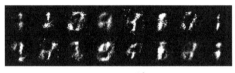

11 EPOCHS

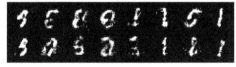

19 EPOCHS

IF YOU KEEP RUNNING MORE EPOCHS...

...EVENTUALLY YOUR RESULTS WILL LOOK LIKE IDENTIFIABLE NUMBERS.

ANAND, I'M GLAD IT WORKED...

... BUT I'M WORRIED THAT THIS MAY BE TOO MUCH FOR MY MACHINE.

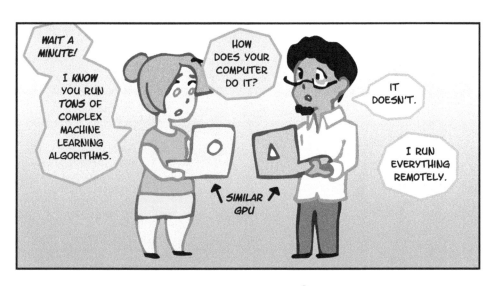

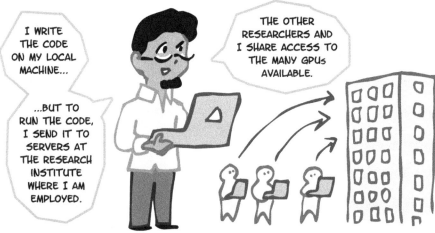

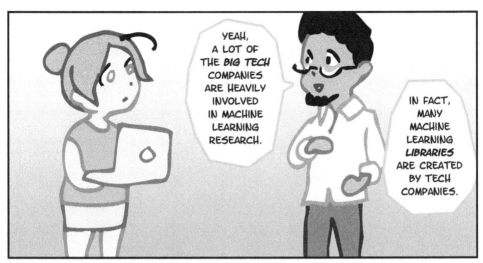

YEAH, A LOT OF THE *BIG TECH* COMPANIES ARE HEAVILY INVOLVED IN MACHINE LEARNING RESEARCH.

IN FACT, MANY MACHINE LEARNING *LIBRARIES* ARE CREATED BY TECH COMPANIES.

PYTORCH, A POPULAR MACHINE LEARNING LIBRARY, WAS DEVELOPED BY RESEARCHERS AT *FACEBOOK* ...

...AND *TENSORFLOW,* WHICH IS PREFERRED FOR MOBILE DEVICES, WAS DEVELOPED BY RESEARCHERS AT *GOOGLE.*

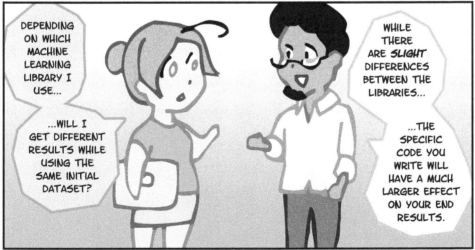

DEPENDING ON WHICH MACHINE LEARNING LIBRARY I USE...

...WILL I GET DIFFERENT RESULTS WHILE USING THE SAME INITIAL DATASET?

WHILE THERE ARE *SLIGHT* DIFFERENCES BETWEEN THE LIBRARIES...

...THE SPECIFIC CODE YOU WRITE WILL HAVE A MUCH LARGER EFFECT ON YOUR END RESULTS.

OKAY, SO NOW I HAVE ACCESS TO PLENTY OF *GPUs*, MACHINE LEARNING *LIBRARIES*, ONLINE *TUTORIALS*, AND YOU TO HELP ME IF I GET STUCK.

BUT THERE'S *ONE MORE* THING I NEED.

THE REASON I AM INTERESTED IN MACHINE LEARNING IN THE FIRST PLACE...

...IS BECAUSE I WANT TO CREATE *NEW IMAGES* BASED ON MY DRAWINGS AND ARTWORK.

SO TO DO THAT...

...I NEED TO CREATE A TRAINING DATASET OF *MY OWN* IMAGES.

I'VE GOT ABOUT 300 PAGES WORTH OF COMICS THAT I'VE MADE.

AND THEY'RE... PRETTY GOOD, YOU KNOW? I'M PROUD OF THEM.

WHAT DO YOU THINK?

CAN I MAKE A TRAINING DATASET OUT OF THESE?

46

WELL, I HATE TO BREAK IT TO YOU, JOYCE...

...BUT THESE IMAGES AREN'T GOING TO WORK WELL AS A TRAINING DATASET.

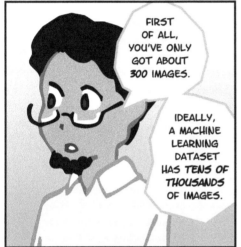

FIRST OF ALL, YOU'VE ONLY GOT ABOUT 300 IMAGES.

IDEALLY, A MACHINE LEARNING DATASET HAS *TENS OF THOUSANDS* OF IMAGES.

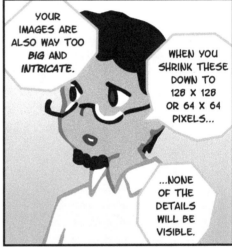

YOUR IMAGES ARE ALSO WAY TOO *BIG* AND *INTRICATE.*

WHEN YOU SHRINK THESE DOWN TO 128 X 128 OR 64 X 64 PIXELS...

...NONE OF THE DETAILS WILL BE VISIBLE.

ESSENTIALLY, FOR YOUR DATASET TO WORK AT ALL...

...YOU'RE GOING TO NEED *MANY MORE* IMAGES, AND THEY NEED TO BE A *LOT* SMALLER.

HMMM

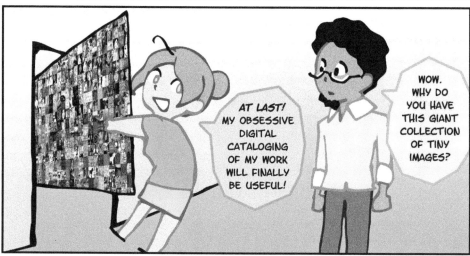

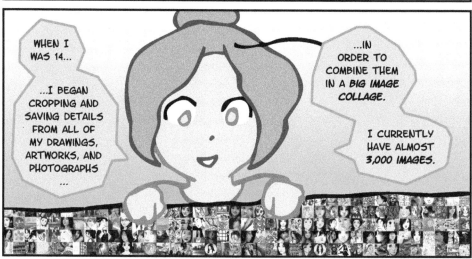

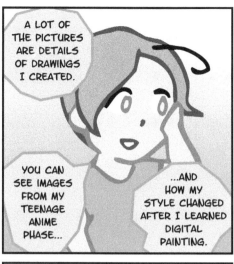

A LOT OF THE PICTURES ARE DETAILS OF DRAWINGS I CREATED.

YOU CAN SEE IMAGES FROM MY TEENAGE ANIME PHASE...

...AND HOW MY STYLE CHANGED AFTER I LEARNED DIGITAL PAINTING.

THERE'S ALSO A LOT OF PICTURES OF MY ABSTRACT DIGITAL ART...

AS WELL AS PHOTOGRAPHS I'VE TAKEN.

SOME OF THE PICTURES ARE MEANT TO BE ARTISTIC...

...AND OTHERS CATALOG WHAT WAS GOING ON IN MY LIFE AT THE TIME.

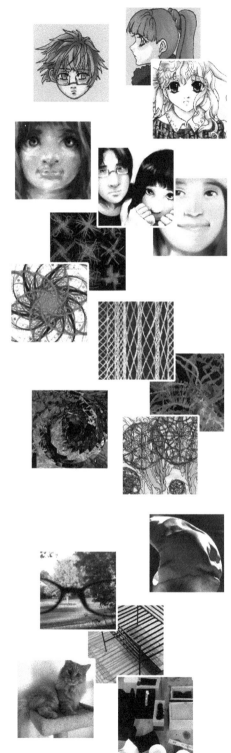

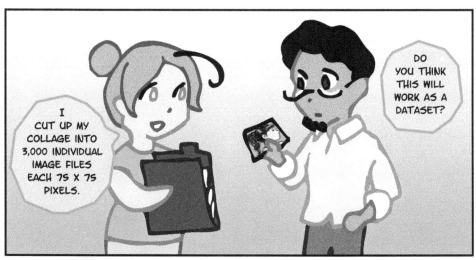

I CUT UP MY COLLAGE INTO 3,000 INDIVIDUAL IMAGE FILES EACH 75 X 75 PIXELS.

DO YOU THINK THIS WILL WORK AS A DATASET?

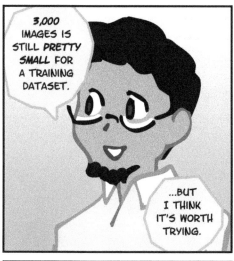

3,000 IMAGES IS STILL PRETTY SMALL FOR A TRAINING DATASET.

...BUT I THINK IT'S WORTH TRYING.

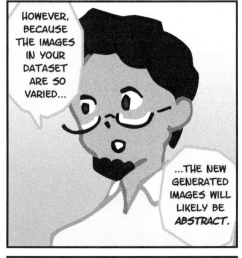

HOWEVER, BECAUSE THE IMAGES IN YOUR DATASET ARE SO VARIED...

...THE NEW GENERATED IMAGES WILL LIKELY BE ABSTRACT.

THAT'S OKAY! I'M REALLY INTERESTED TO SEE WHAT TYPES OF IMAGES ARE CREATED ...

EVEN IF THEY ARE NON-REPRESEN-TATIONAL.

SEEING THE ABSTRACT IMAGES GENERATED FROM MY DATASET MIGHT GIVE ME NEW INSIGHT INTO MY OWN AESTHETIC CHOICES.

SO MAKE SURE THE FILE FORMAT YOU ARE SAVING YOUR IMAGES AS...

ALRIGHT THEN. TO USE YOUR DATASET ...

...IT HAS TO BE ACCESSIBLE TO YOUR PROGRAM.

...IS THE SAME FILE FORMAT THAT YOUR CODE IS EXPECTING.

IF YOU'RE RUNNING CODE ONLINE, YOU'LL NEED TO UPLOAD YOUR DATASET AND ALLOW ACCESS.

YOU CAN DO THIS WITHOUT MAKING THE DATASET PUBLIC.

ALRIGHT. I BELIEVE I'VE GOT EVERYTHING SET UP AS BEST I CAN.

TIME TO RUN SOME CODE!

NOW WE GET TO WATCH THE RESULTS COME IN.

AGAIN, FOR THE FIRST FEW EPOCHS...

...THE GENERATED IMAGES ARE GRAINY AND ALL VERY SIMILAR.

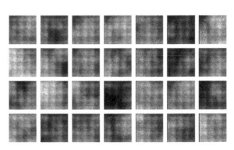

3,000 IMAGE DATASET
5 EPOCHS
64 X 64 PIXELS

WE'LL WANT TO SEE IMAGES BECOME MORE COMPLEX...

...AND MORE DISTINCT FROM EACH OTHER.

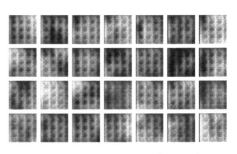

3,000 IMAGE DATASET
20 EPOCHS
64 X 64 PIXELS

SEE? THESE IMAGES ARE BECOMING DISTINCT...

...BUT WE'RE STILL SEEING SOME REPETITION WITHIN THE IMAGES, WHICH ISN'T IDEAL.

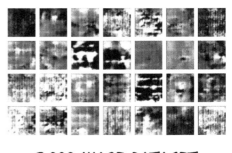

3,000 IMAGE DATASET
100 EPOCHS
64 X 64 PIXELS

52

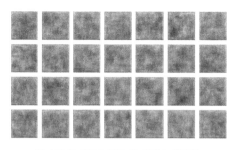

3,000 IMAGE DATASET
5 EPOCHS
128 X 128 PIXELS

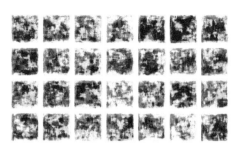

3,000 IMAGE DATASET
20 EPOCHS
128 X 128 PIXELS

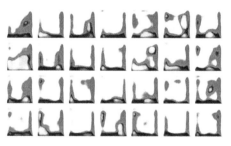

3,000 IMAGE DATASET
100 EPOCHS
128 X 128 PIXELS

WOW, THESE RESULTS LOOK VERY DIFFERENT THAN THE PREVIOUS ONES.

YES, USING A DIFFERENT GAN CAN GIVE YOU DRASTICALLY DIFFERENT RESULTS.

IN THIS CASE, THE GENERATED IMAGES ARE ALL VERY SIMILAR TO EACH OTHER, WHICH WE GENERALLY DON'T WANT TO SEE IN GAN RESULTS.

THIS MEANS YOU NEED TO LET THE PROGRAM RUN FOR MANY MORE EPOCHS.

I SEE.

I FEEL LIKE I DON'T HAVE A CLEAR UNDERSTANDING OF HOW CHANGES IN THE CODE AFFECTS MY RESULTS.

I STILL HAVE MUCH MORE TO LEARN!

EVEN SO, YOU SHOULD BE EXCITED!

YOU'VE ACCOMPLISHED A LOT.

I GUESS SO.

AFTER *A BIT* OF DEBUGGING AND *MORE THAN A FEW* FRUSTRATING ERRORS, I WAS ABLE TO GENERATE SOME IMAGES.

YEAH ... I'VE LEARNED A LOT *FOR A FEW* DAYS.

BUT I FEEL LIKE I *HAVEN'T* GOTTEN ANY RESULTS THAT I'M *REALLY* EXCITED ABOUT.

WELL, LET'S SEE IF WE CAN FIX THAT IN THE NEXT CHAPTER.

4
IMPROVING RESULTS

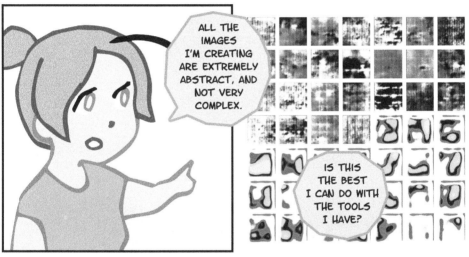

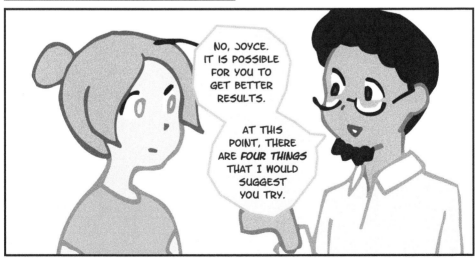

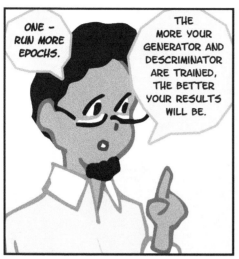

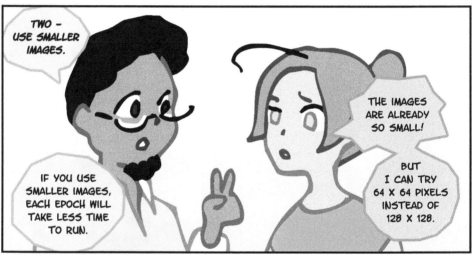

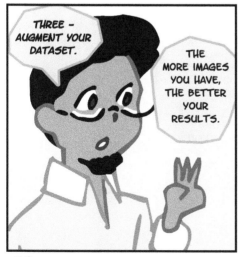

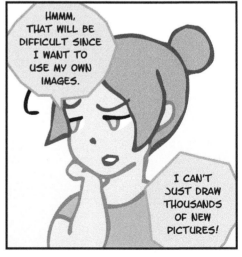

YOU CAN STILL INCREASE YOUR DATASET.

FROM A COMPUTER'S PERSPECTIVE, A FLIPPED OR ROTATED IMAGE IS A NEW IMAGE.

DIFFERENT IMAGES
(FROM A COMPUTER'S PERSPECTIVE)

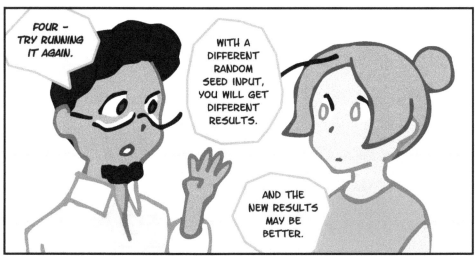

FOUR - TRY RUNNING IT AGAIN.

WITH A DIFFERENT RANDOM SEED INPUT, YOU WILL GET DIFFERENT RESULTS.

AND THE NEW RESULTS MAY BE BETTER.

KEEP IN MIND, WE DON'T KNOW EXACTLY WHY GANs WORK* ...

...SO THERE IS NO WAY TO 100% GUARANTEE THAT YOU WILL GET GOOD RESULTS.

*THERE ARE STILL MANY OPEN RESEARCH PROBLEMS SURROUNDING GANs

ALL RIGHT— SO THE FIRST THING I WILL DO IS *INCREASE THE SIZE OF MY DATASET.*

JUST BY FLIPPING THE IMAGES, I CAN DOUBLE IT IN SIZE!

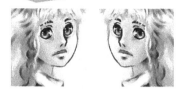

2X

AND BY ALSO ROTATING THE IMAGES, I CAN *TRIPLE* THE ALREADY DOUBLED SIZE!

6X

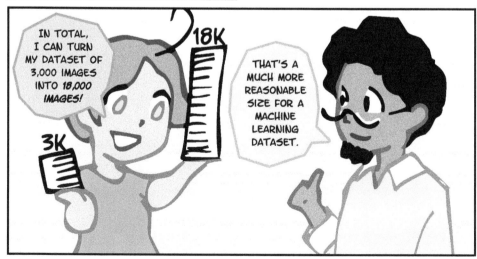

IN TOTAL, I CAN TURN MY DATASET OF 3,000 IMAGES INTO *18,000 IMAGES!*

18K

3K

THAT'S A MUCH MORE REASONABLE SIZE FOR A MACHINE LEARNING DATASET.

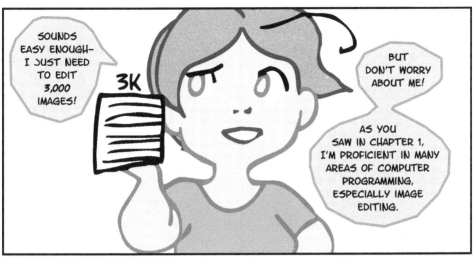

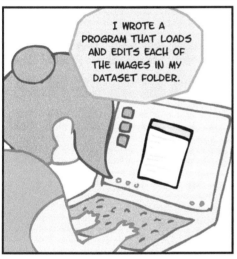

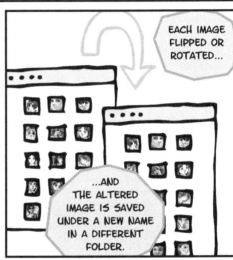

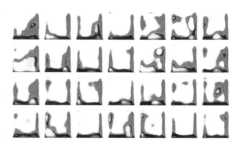

3,000 IMAGE DATASET
100 EPOCHS
128 X 128 PIXELS

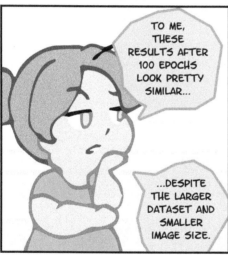

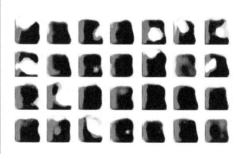

18,000 IMAGE DATASET
100 EPOCHS
64 X 64 PIXELS

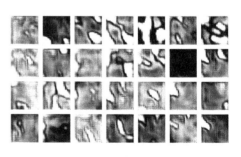

18,000 IMAGE DATASET
700 EPOCHS
64 X 64 PIXELS

SO MUCH BETTER, RIGHT?

YEAH, BUT THESE RESULTS STILL AREN'T GREAT.

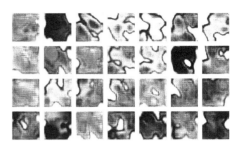

18,000 IMAGE DATASET
1000 EPOCHS
64 X 64 PIXELS

SEE HOW SIMILAR ALL THE IMAGES ARE TO EACH OTHER?

IDEALLY, YOU SHOULD BE SEEING MORE VARIED IMAGES.

MAYBE IT'S JUST NOT RUNNING FOR ENOUGH EPOCHS...

...OR DO I NEED TO FIX SOMETHING IN THE CODE?

WE COULD TRY LOOKING AT THE CODE MORE IN DEPTH, BUT IT MIGHT TAKE A WHILE TO FIND A SOLUTION, IF THERE IS ONE.

HMMM. BEFORE WE DEVOTE A LOT OF TIME TO DOING THAT...

...WHY DON'T I TRY THE NEW DATASET WITH THE FIRST GAN* I WAS USING IN CHAPTER 3?

SOUNDS GOOD.

*PAGE 52

ALRIGHT, BACK TO THE FIRST EXAMPLE.

AS A REMINDER, THIS IS WHAT I WAS ABLE TO MAKE PREVIOUSLY.

**3,000 IMAGE DATASET
100 EPOCHS
64 X 64 PIXELS**

I WAS ALREADY USING 64 X 64 PIXEL IMAGES...

...SO I WON'T BE MAKING THE IMAGES ANY SMALLER.

BUT HOPEFULLY THE LARGER DATASET WILL MAKE A DIFFERENCE IN MY RESULTS.

OOOH! LOOK AT THAT!

THEY'RE STILL ABSTRACT, BUT SOME LOOK LIKE ACTUAL IMAGES.

KINDA ARTISTIC, EVEN.

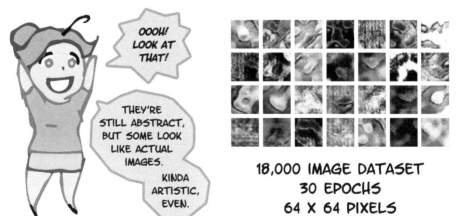

**18,000 IMAGE DATASET
30 EPOCHS
64 X 64 PIXELS**

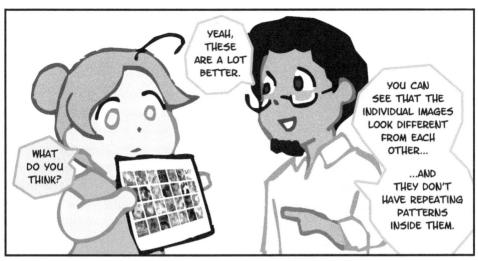

YEAH, YOU NEED MORE TIME TO RUN THE CODE.

BUT I'M NOT GOING TO GET UNLIMITED TIME, ESPECIALLY IF I WANT TO USE A FREE SERVICE.

IT'S JUST SO FRUSTRATING THAT ALL *THE WORK* THAT GOES INTO TRAINING THE GENERATOR AND DISCRIMINATOR *DISAPPEARS* AS SOON AS THE PROGRAM FINISHES RUNNING.

THE EXAMPLE IMAGES ARE SAVED...

...BUT ALL THE TRAINING NEEDED TO GENERATE THEM JUST GOES 'POOF'

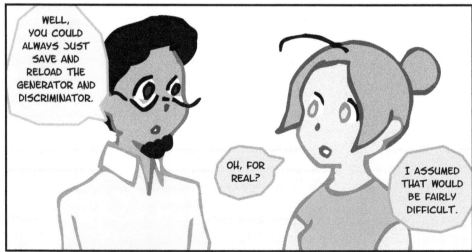

WELL, YOU COULD ALWAYS JUST SAVE AND RELOAD THE GENERATOR AND DISCRIMINATOR.

OH, FOR REAL?

I ASSUMED THAT WOULD BE FAIRLY DIFFICULT.

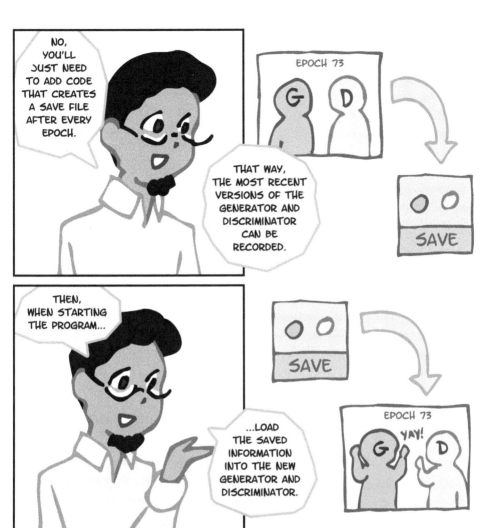

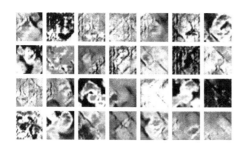

18,000 IMAGE DATASET
30 EPOCHS (VERSION 1)
64 X 64 PIXELS

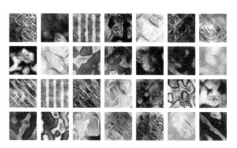

18,000 IMAGE DATASET
49 EPOCHS (VERSION 1)
64 X 64 PIXELS

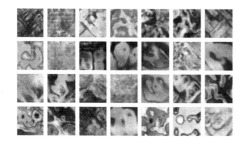

18,000 IMAGE DATASET
81 EPOCHS (VERSION 1)
64 X 64 PIXELS

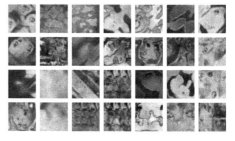

18,000 IMAGE DATASET
107 EPOCHS (VERSION 1)
64 X 64 PIXELS

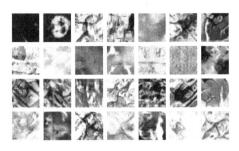

18,000 IMAGE DATASET
62 EPOCHS (VERSION 2)
64 X 64 PIXELS

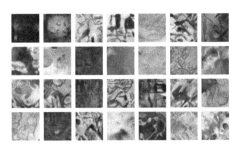

18,000 IMAGE DATASET
117 EPOCHS (VERSION 2)
64 X 64 PIXELS

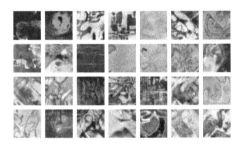

18,000 IMAGE DATASET
180 EPOCHS (VERSION 2)
64 X 64 PIXELS

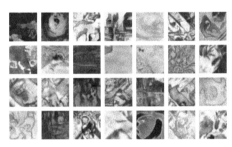

18,000 IMAGE DATASET
219 EPOCHS (VERSION 2)
64 X 64 PIXELS

NEAT! THE RESULTS ARE PRETTY ABSTRACT...

...BUT I FEEL LIKE I CAN SEE ECHOES OF MY IMAGES IN THESE.

AESTHETIC VALUE CAN BE SUBJECTIVE...

...BUT, PERSONALLY, I LIKE THEM.

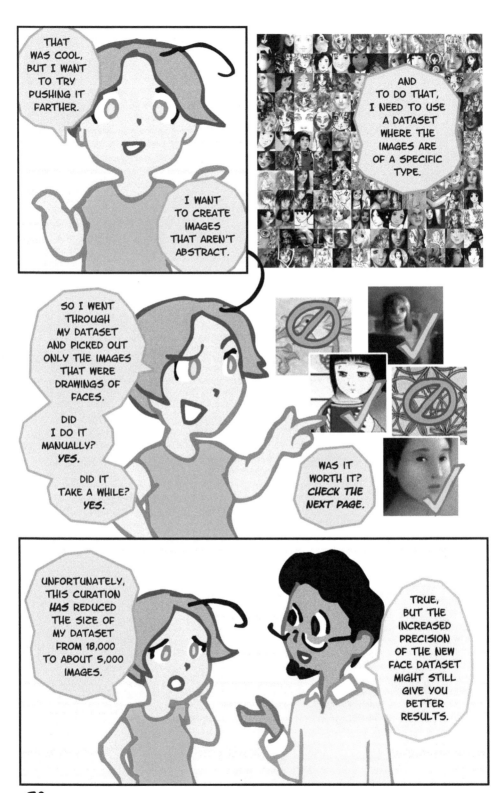

THAT WAS COOL, BUT I WANT TO TRY PUSHING IT FARTHER.

I WANT TO CREATE IMAGES THAT AREN'T ABSTRACT.

AND TO DO THAT, I NEED TO USE A DATASET WHERE THE IMAGES ARE OF A SPECIFIC TYPE.

SO I WENT THROUGH MY DATASET AND PICKED OUT ONLY THE IMAGES THAT WERE DRAWINGS OF FACES.

DID I DO IT MANUALLY? YES.

DID IT TAKE A WHILE? YES.

WAS IT WORTH IT? CHECK THE NEXT PAGE.

UNFORTUNATELY, THIS CURATION HAS REDUCED THE SIZE OF MY DATASET FROM 18,000 TO ABOUT 5,000 IMAGES.

TRUE, BUT THE INCREASED PRECISION OF THE NEW FACE DATASET MIGHT STILL GIVE YOU BETTER RESULTS.

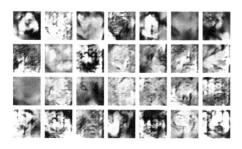

**5,000 FACE DATASET
65 EPOCHS
64 X 64 PIXELS**

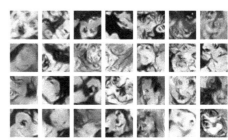

**5,000 FACE DATASET
164 EPOCHS
64 X 64 PIXELS**

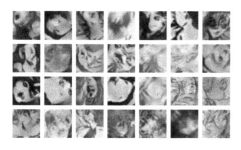

**5,000 FACE DATASET
310 EPOCHS
64 X 64 PIXELS**

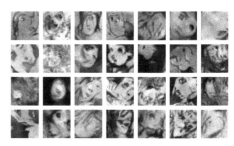

**5,000 FACE DATASET
456 EPOCHS
64 X 64 PIXELS**

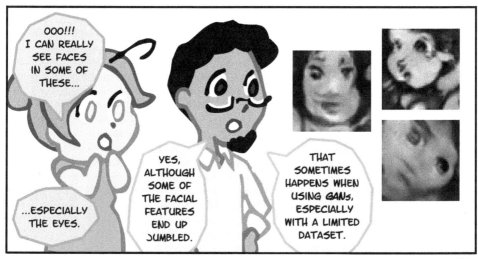

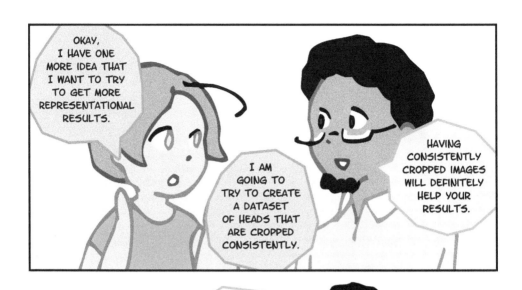

OKAY, I HAVE ONE MORE IDEA THAT I WANT TO TRY TO GET MORE REPRESENTATIONAL RESULTS.

I AM GOING TO TRY TO CREATE A DATASET OF HEADS THAT ARE CROPPED CONSISTENTLY.

HAVING CONSISTENTLY CROPPED IMAGES WILL DEFINITELY HELP YOUR RESULTS.

UNFORTUNATELY, YOU'LL HAVE TO CROP THE IMAGES YOURSELF.*

*COLLEGE STUDENTS AND SCIENTISTS HAVE TO DO THIS WHEN CREATING NEW DATASETS.

IT WILL TAKE TIME, BUT I CAN DO IT.

FOR THIS DATASET, I'M JUST GOING TO USE ALL THE HEADS IN THE *COMICS* I'VE MADE...

COMICS

...INSTEAD OF MY *ENTIRE CATALOG* OF DRAWN IMAGES.

OTHER

TO MAKE IT A *LITTLE* EASIER ON MYSELF, I CREATED A PROGRAM THAT LOADS EACH COMIC PAGE FOR ME.

WITH *TWO MOUSE CLICKS*, I DEFINE THE POSITION OF EACH CROPPED HEAD.

AND WHEN I HIT 'ENTER,' THE CROPPED AREAS ARE SAVED AS IMAGE FILES...

...AND THE NEXT COMIC PAGE APPEARS ON THE SCREEN.

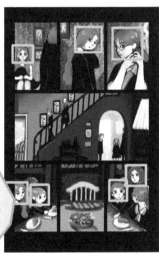

I STILL HAVE TO POINT OUT ALL THE HEADS MYSELF...

...BUT I SAVE A *LOT OF TIME* NAMING AND SAVING FILES.

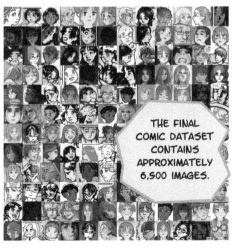

THE FINAL COMIC DATASET CONTAINS APPROXIMATELY 6,500 IMAGES.

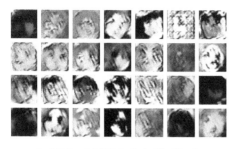

6,500 COMIC DATASET
40 EPOCHS
64 X 64 PIXELS

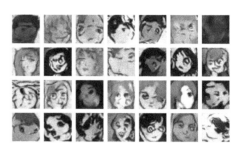

6,500 COMIC DATASET
119 EPOCHS
64 X 64 PIXELS

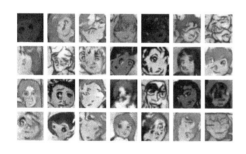

6,500 COMIC DATASET
190 EPOCHS
64 X 64 PIXELS

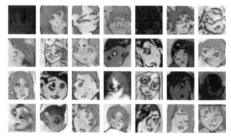

6,500 COMIC DATASET
270 EPOCHS
64 X 64 PIXELS

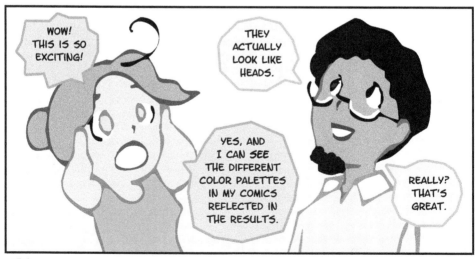

YEAH, I'VE DONE A LOT OF DRAWINGS OF REDHEADS, SO YOU CAN SEE SEVERAL OF THOSE.

THEN THERE ARE ONES THAT ARE NEUTRAL COLORS.

AND SOME GREEN AND PURPLE ONES, TOO.

ALTHOUGH, SOME BARELY RESEMBLE FACES.

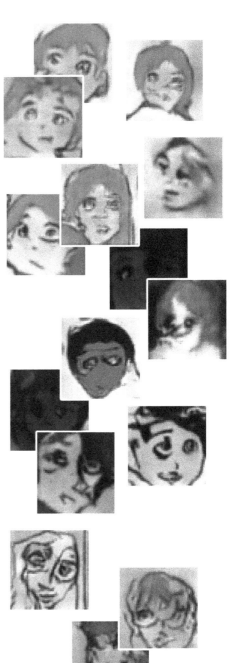

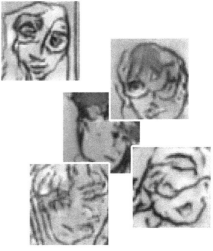

YOU SEE? HAVING AN ADEQUATE DATASET MAKES ALL OF THE DIFFERENCE.

YEAH, AFTER I DRAW MORE IMAGES FOR MY DATASET...

...OR I FIND A NEW ALGORITHM OR APPROACH ...

...I'LL MAKE MORE NEURAL NETS.

DID YOU ENJOY USING GANs TO GENERATE IMAGES?

I LIKE THE IMAGES...

....BUT THE CREATION PROCESS TOOK SOME GETTING USED TO.

COMPARED TO MY OTHER WORK, I FEEL LIKE I HAVE WAY **LESS CONTROL** OVER THE FINAL RESULT.

YES, MACHINE LEARNING CAN OFTEN BE CHALLENGING.

A LOT OF THE WORK WE DO IS TRYING TO GET **CONSISTENT** RESULTS.

THIS IS ESPECIALLY IMPORTANT WHEN DESIGNING A NEURAL NETWORK THAT PERFORMS **CRITICAL TASKS**, SUCH AS THOSE IN CARS OR HOSPITALS.

YES, BUT ON THE OTHER HAND, FOR THE FIRST TIME I FEEL LIKE THE COMPUTER IS A *COLLABORATOR*...

...RATHER THAN A *TOOL* THAT I DICTATE *INSTRUCTIONS* TO.

BECAUSE I WORK WITH ELECTRONICS ALL THE TIME...

...IT'S VERY EXCITING TO SEE TECHNOLOGY THAT IS ABLE TO SURPRISE ME...

...EVEN IF THAT MEANS IT'S HARDER TO GET IT TO DO WHAT I WANT.

AND THAT IS BOTH THE CHALLENGE AND THE FUN OF ANY TRUE COLLABORATION.

YEAH, EXACTLY.

5

MORE WAYS TO TRANSFORM IMAGES

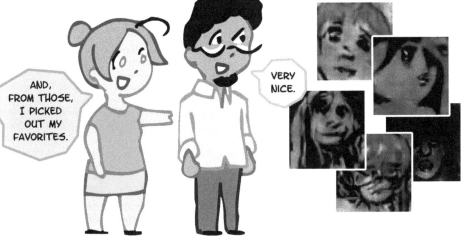

*IN THE END, I DECIDED TO MAKE A WHOLE COMIC ABOUT THEM!

AS A REMINDER, THIS IS THE ACTUAL SIZE OF THE IMAGES

ZOOMED IN

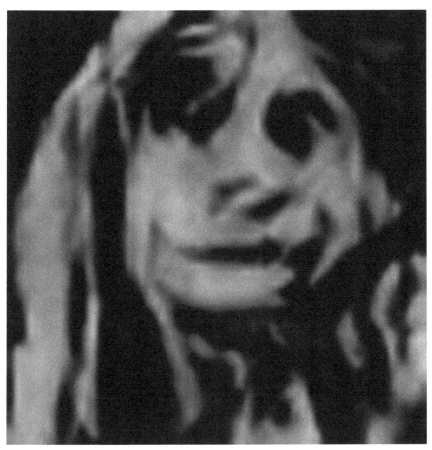

RESIZED USING PHOTOSHOP

WHEN MAKING AN IMAGE LARGER...

...THE GOAL IS TO CREATE COLOR TRANSITIONS BETWEEN DIFFERENT PIXELS.

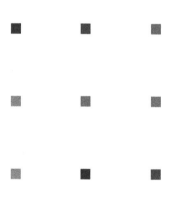

IT'S AS THOUGH WE ARE SPREADING THE ORIGINAL PIXELS FURTHER APART...

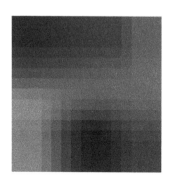

...AND THEN ADDING ADDITIONAL COLORS THAT BEST REFLECT THE ORIGINAL IMAGE.

83

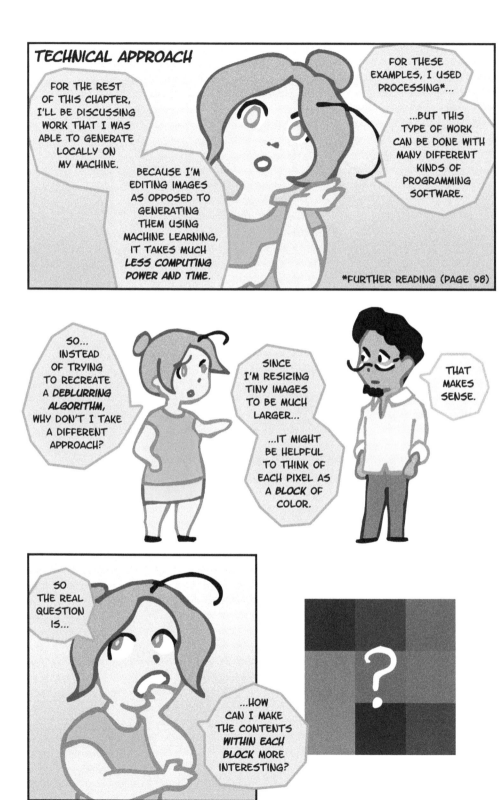

TECHNICAL APPROACH

FOR THE REST OF THIS CHAPTER, I'LL BE DISCUSSING WORK THAT I WAS ABLE TO GENERATE LOCALLY ON MY MACHINE.

BECAUSE I'M EDITING IMAGES AS OPPOSED TO GENERATING THEM USING MACHINE LEARNING, IT TAKES MUCH *LESS COMPUTING POWER AND TIME.*

FOR THESE EXAMPLES, I USED PROCESSING*...

...BUT THIS TYPE OF WORK CAN BE DONE WITH MANY DIFFERENT KINDS OF PROGRAMMING SOFTWARE.

*FURTHER READING (PAGE 98)

SO... INSTEAD OF TRYING TO RECREATE A *DEBLURRING ALGORITHM,* WHY DON'T I TAKE A DIFFERENT APPROACH?

SINCE I'M RESIZING TINY IMAGES TO BE MUCH LARGER...

...IT MIGHT BE HELPFUL TO THINK OF EACH PIXEL AS A *BLOCK* OF COLOR.

THAT MAKES SENSE.

SO THE REAL QUESTION IS...

...HOW CAN I MAKE THE CONTENTS *WITHIN EACH BLOCK* MORE INTERESTING?

BECAUSE I KNOW THE POSITION AND COLOR OF EACH BLOCK...

...I CAN ALSO FIND THE COLORS OF ALL THE NEARBY BLOCKS.

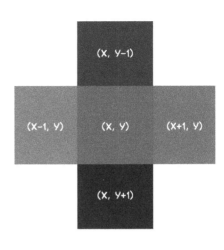

USING THAT INFORMATION, I CAN HAVE THIS BLOCK INCLUDE THE COLORS OF ITS NEIGHBORS.

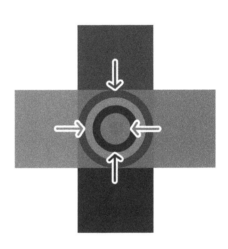

DO THE SAME THING TO EVERY BLOCK...

...AND THE RESULTING IMAGE NOW HAS A UNIQUE TEXTURE.

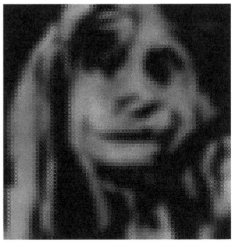

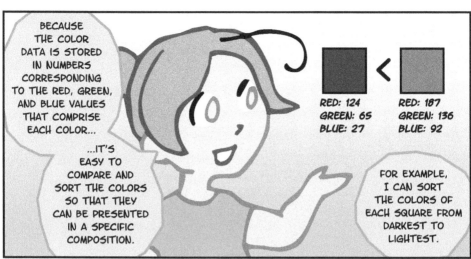

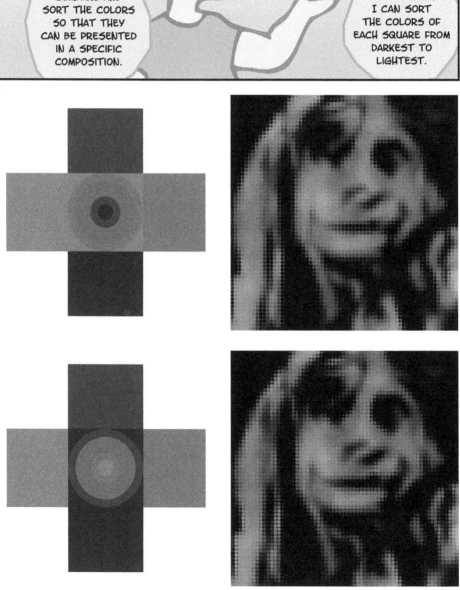

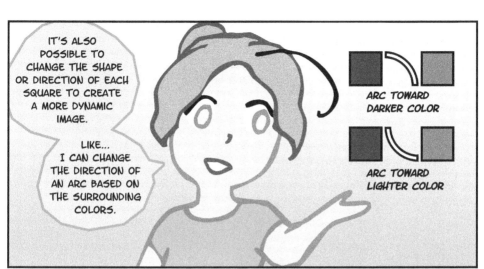

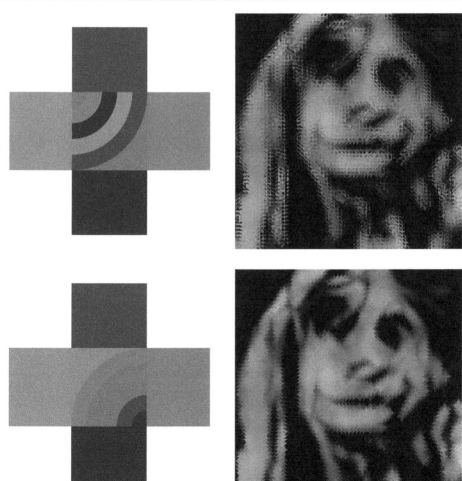

NEXT, I'LL TRY SOMETHING THAT DOESN'T STICK TO THE 'BLOCKS' OF THE ORIGINAL IMAGE.

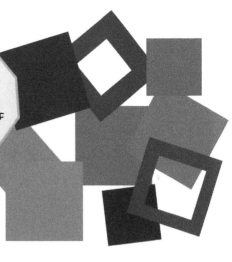

INSTEAD, I'M GOING TO TRY DRAWING SHAPES ALL OVER THE IMAGE USING *RANDOMIZED* POSITIONS AND SIZES.

IF ENOUGH RANDOM SHAPES ARE CREATED, THEY WILL FILL UP THE ENTIRE IMAGE.

BY REDUCING THE TRANSPARENCY OF EACH NEW SHAPE, THE HUNDREDS OF OVERLAYING SHAPES CAN CREATE A VISUAL TEXTURE.

AND BY REFERENCING THE COLOR DATA FROM THE ORIGINAL IMAGE...

...EACH NEW SHAPE CAN BE FILLED WITH THE COLORS OF THE PIXELS THAT IT IS CLOSEST TO.

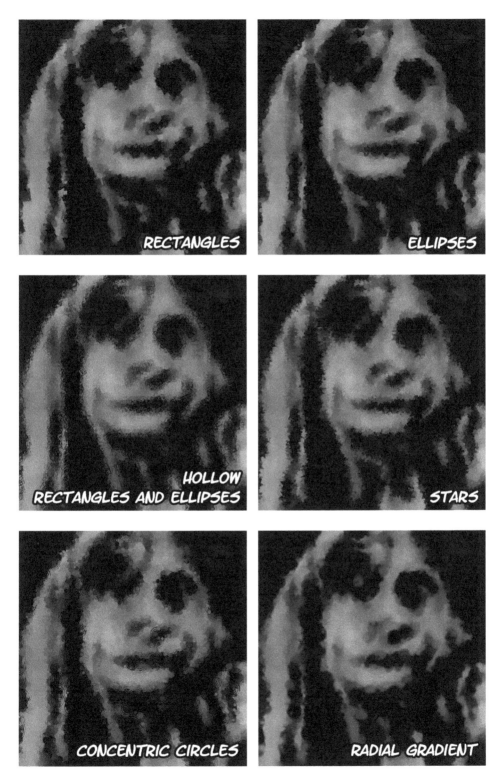

89

IN THE PREVIOUS EXAMPLE, THE SHAPES WERE BEING POSITIONED RANDOMLY.

LET'S LOOK AT SOMETHING A LITTLE MORE ORGANIZED.

BY LAYERING SEVERAL *TRANSLUCENT ELLIPSES* ON TOP OF EACH OTHER...

...IT'S POSSIBLE TO CREATE A DIGITAL TEXTURE THAT LOOKS LIKE A *BRUSH STROKE.*

THE RESULTS AREN'T EXACTLY THE TEXTURE OF A *REAL PAINTBRUSH...*

...BUT THEY CAN BE VISUALLY INTERESTING.

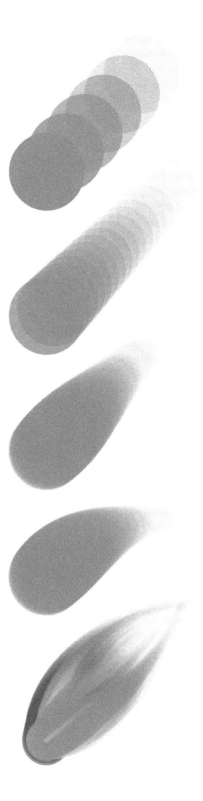

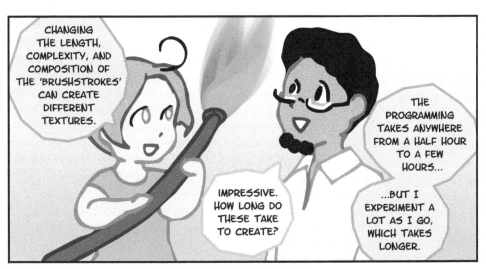

TEXTURE DETAILS

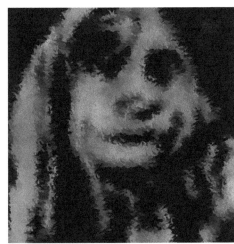

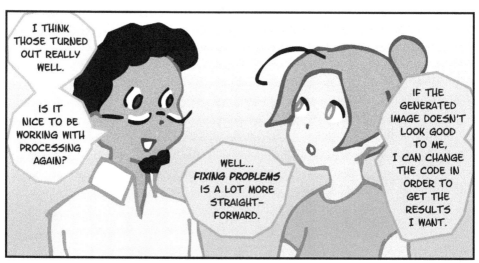

I THINK THOSE TURNED OUT REALLY WELL.

IS IT NICE TO BE WORKING WITH PROCESSING AGAIN?

WELL... FIXING PROBLEMS IS A LOT MORE STRAIGHT-FORWARD.

IF THE GENERATED IMAGE DOESN'T LOOK GOOD TO ME, I CAN CHANGE THE CODE IN ORDER TO GET THE RESULTS I WANT.

I SEE.

YOU GET MORE PREDICTABLE RESULTS.

YEAH, BECAUSE I'M TELLING THE PROGRAM EXACTLY WHAT TO DO....

...THE END RESULT ISN'T AS SURPRISING AS IT WAS WHEN I WAS EXPERIMENTING WITH MACHINE LEARNING.

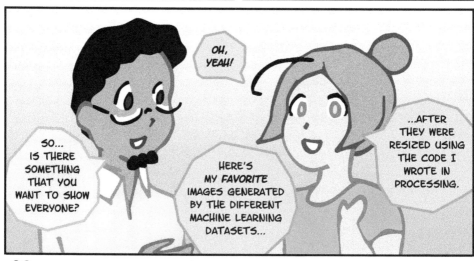

SO... IS THERE SOMETHING THAT YOU WANT TO SHOW EVERYONE?

OH, YEAH!

HERE'S MY FAVORITE IMAGES GENERATED BY THE DIFFERENT MACHINE LEARNING DATASETS...

...AFTER THEY WERE RESIZED USING THE CODE I WROTE IN PROCESSING.

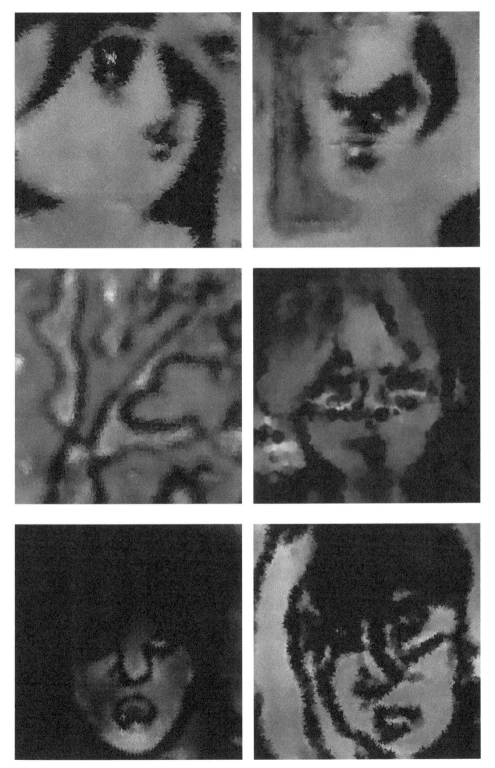

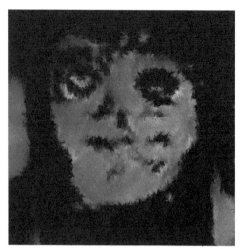
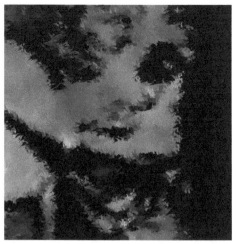
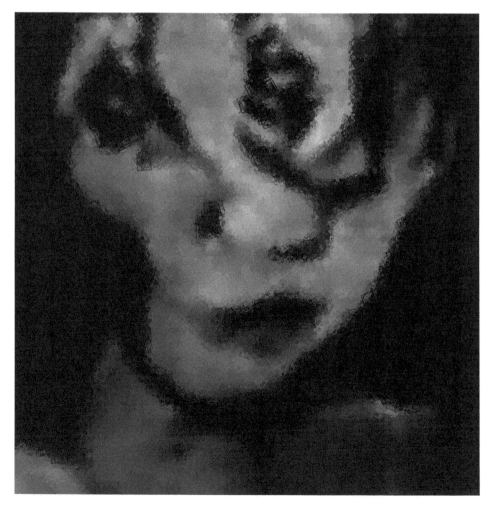

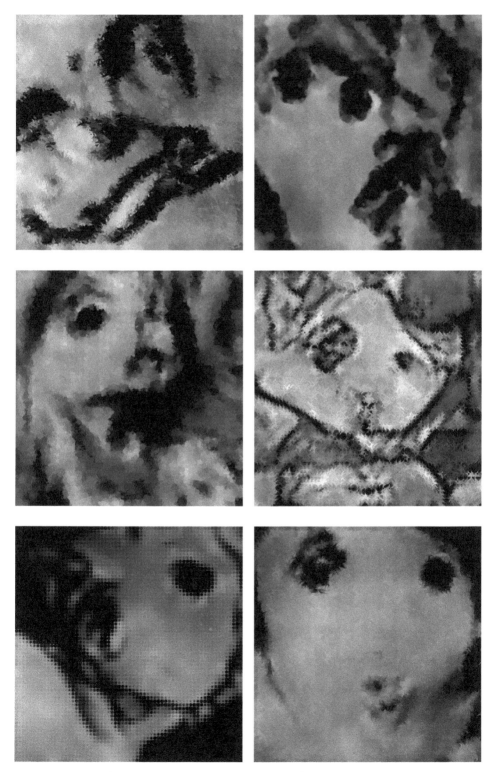

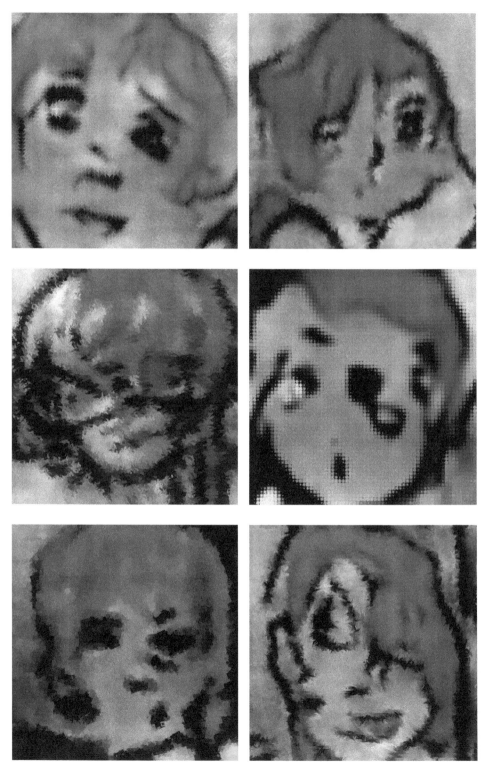

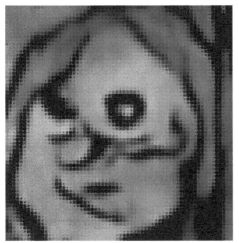
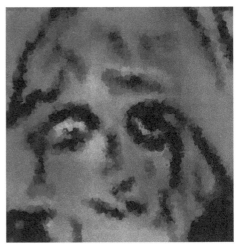
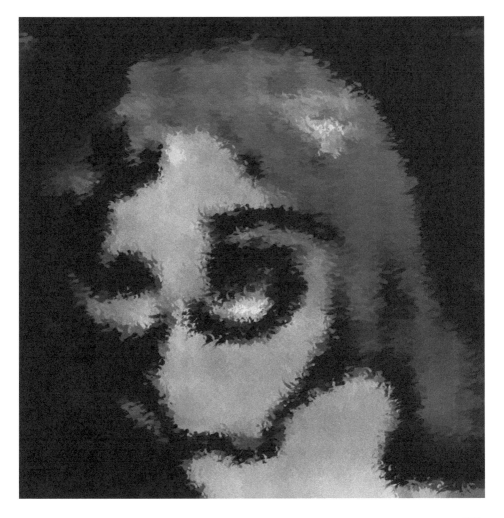

FURTHER READING

IF YOU WANT TO LEARN MORE, HERE ARE SOME RESOURCES YOU CAN CHECK OUT.

GENERATING IMAGES AND ANIMATION

IF YOU ARE INTERESTED IN MY WORK WITH PROCESSING AND JAVASCRIPT, CHECK OUT THESE RESOURCES.

THERE ARE MANY TUTORIALS AND REFERENCES AVAILABLE, SO THEY ARE GOOD PLACES TO GET STARTED.

PROCESSING.ORG
P5JS.ORG
JAVASCRIPT.COM

GROSS, B., BOHNACKER, H., LAUB, J., AND LAZZERONI, C. (2018). *GENERATIVE DESIGN*. PRINCETON ARCHITECTURAL PRESS.

REAS, C., AND FRY, B. (2014). *PROCESSING: A PROGRAMMING HANDBOOK FOR VISUAL DESIGNERS AND ARTISTS*. MIT PRESS.

SHIFFMAN, D. (2008). *LEARNING PROCESSING: A BEGINNER'S GUIDE TO PROGRAMMING IMAGES, ANIMATION, AND INTERACTION*.

SHIFFMAN, D. (2012). *THE NATURE OF CODE*.

SOON, W., AND COX, G. (2020). *AESTHETIC PROGRAMMING: A HANDBOOK OF SOFTWARE STUDIES*. OPEN HUMANITIES PRESS.

MACHINE LEARNING FOR BEGINNERS

FERRIE, C., AND KAISER, S. (2019). *NEURAL NETWORKS FOR BABIES.* SOURCEBOOKS EXPLORE.

HARDT, M., AND RECHT, B. (2021). *PATTERNS PREDICTIONS, AND ACTIONS: A STORY ABOUT MACHINE LEARNING.* MLSTORY.ORG

MACHINE LEARNING FOR PROGRAMMERS

GERARD, C. (2021). *LEARNING IN JAVASCRIPT: TENSORFLOW.JS FOR WEB DEVELOPERS.* APRESS.

RASCHKA, S., AND MIRJALILI, V. (2019). *PYTHON MACHINE LEARNING: MACHINE LEARNING AND DEEP LEARNING WITH PYTHON, SCIKIT-LEARN, AND TENSORFLOW 2, 3RD EDITION.* PACKT PUBLISHING.

HERE ARE SOME RESOURCES FOR MACHINE LEARNING.

THERE ARE MANY BOOKS AVAILABLE FOR BOTH BEGINNERS AND PROGRAMMERS...

ONLINE EXAMPLES

BROWNLEE, J. (2019). "YOUR FIRST MACHINE LEARNING PROJECT IN PYTHON STEP-BY-STEP." *MACHINE LEARNING MASTERY.* MACHINELEARNINGMASTERY.COM

"CREATIVE TOOLS TO GENERATE AI ART." *AIARTISTS.* AIARTISTS.ORG/AI-GENERATED-ART-TOOLS

GEITGEY, A. (2014). "MACHINE LEARNING IS FUN!" MEDIUM.COM

...AS WELL AS ONLINE EXAMPLES.

"GENERATIVE ADVERSARIAL NETWORKS WITH PYTORCH." *ALGORITHMIC ART.* ALGORITHMICARTMEETUP.BLOGSPOT.COM

MACHINE LEARNING FOR ARTISTS. ML4A.GITHUB.IO

TOWARDS DATA SCIENCE. TOWARDSDATASCIENCE.COM

BONUS!

I CREATED A DATASET OF ALL OF THE DRAWINGS
OF JOYCE AND ANAND AND TRAINED A GAN WITH THEM.

EVEN WITH ALL THE DRAWINGS FROM THIS BOOK, MY COLLECTION IS STILL VERY
SMALL FOR A TRAINING DATASET. BUT THE SIMILARITY OF THE IMAGES AND MY
CONSISTENT CROPPING SHOULD HELP WITH THE RESULTS.

TO SUPPLEMENT THE ORIGINAL DATASET, I ALSO INCLUDED ALTERED VERSIONS:
IMAGES FLIPPED, ROTATED FORWARD AND BACKWARD 15 DEGREES, AND ROTATED
FORWARD AND BACKWARD 30 DEGREES.

JOYCE-ANAND "JOYANA" DATASET

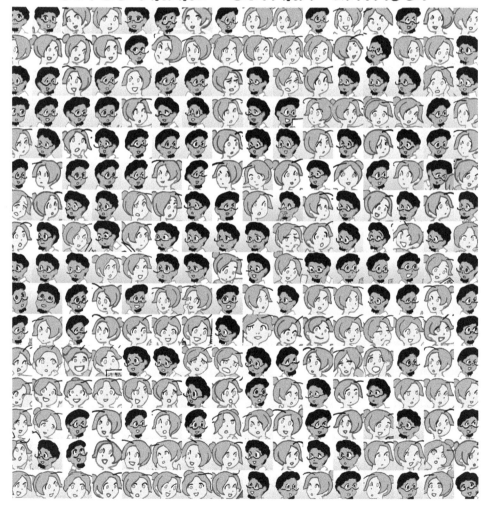

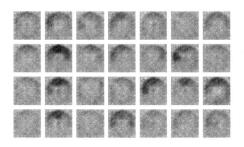

3220 JOYANA DATASET
3 EPOCHS
64 X 64 PIXELS

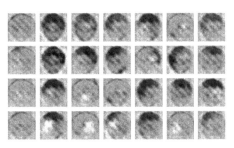

3220 JOYANA DATASET
15 EPOCHS
64 X 64 PIXELS

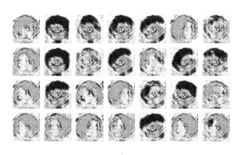

3220 JOYANA DATASET
42 EPOCHS
64 X 64 PIXELS

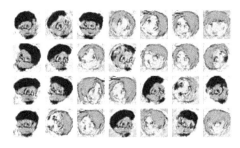

3220 JOYANA DATASET
81 EPOCHS
64 X 64 PIXELS

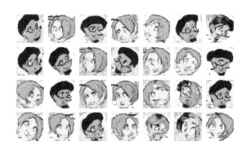

3220 JOYANA DATASET
201 EPOCHS
64 X 64 PIXELS

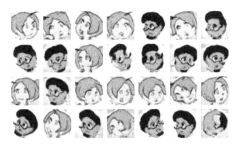

3220 JOYANA DATASET
357 EPOCHS
64 X 64 PIXELS

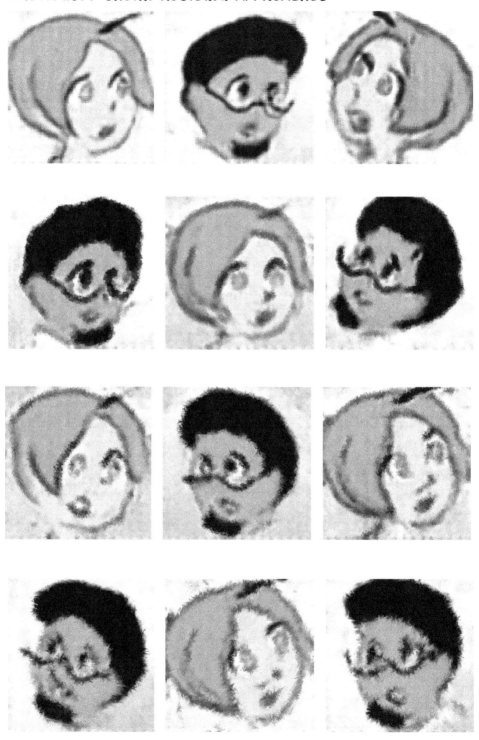

RESIZING WITH VECTORS

I ALSO WANTED TO SEE WHAT TYPE OF RESIZED IMAGES I COULD CREATE IF I USED THE TOOLS AVAILABLE IN PROGRAMS SUCH AS PHOTOSHOP AND ILLUSTRATOR.

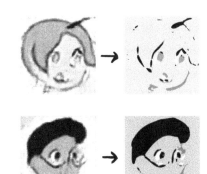

IN THIS CASE, I USED SEVERAL DIFFERENT METHODS TO VECTORIZE PARTS OF THE IMAGES, AND THEN OVERLAID THE SHAPES TO CREATE THE FINISHED PIECES.

THE RESULTS ARE STILL VISUALLY DISTINCT FROM THE PICTURES IN THE DATASET.

HOWEVER, THEY DO RECREATE THE SOLID AREAS OF COLOR AND FLATTENED LOOK OF THE ORIGINAL IMAGES BETTER.

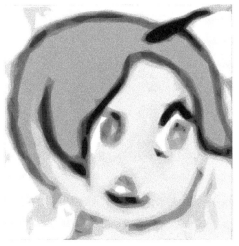

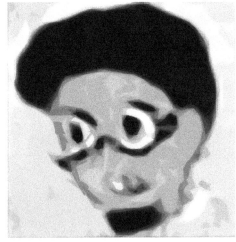

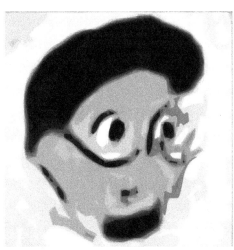

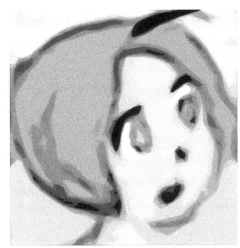

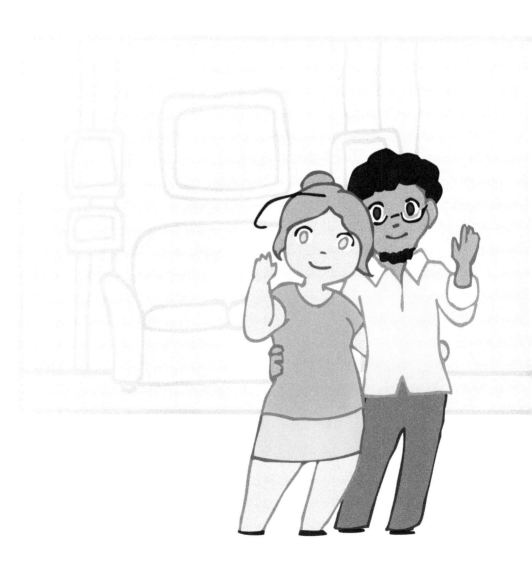

CPSIA information can be obtained
at www.ICGtesting.com
Printed in the USA
BVHW050409220721
612423BV00022B/1180